ellsworth kelly

St IVES

TATE

First published 2007 by order of the Tate Trustees by Tate St Ives in association with
Tate Publishing, a division of Tate Enterprises Ltd, Millbank, London SW1P 4RG
www.tate.org.uk www.tate.org.uk/publishing

This catalogue has been published to celebrate the exhibition
Ellsworth Kelly in St Ives, 28 January – 7 May 2006

The exhibition and publication has been supported by:
Tate St Ives Members and Tate Members

British Library Cataloguing in Publication Data:
A catalogue record of this book is available from the British Library
ISBN No: 978-1-85437-630-5
Library of Congress No: 2005937951

Modern Icons: The Contradictions of Ellsworth Kelly by Christoph Grunenberg

Edited by Susan Daniel-McElroy, Sara Hughes, Alex Lambley, Arwen Fitch and Kerry Rice
Design by Andrew Smith Print by Andrew Keeble Associates

Measurements of artworks given in centimetres, height and width

Ellsworth Kelly: A Retrospective opened 18 October 1996 – 15 January 1997 at the
Guggenheim Museum, New York before touring to the Museum of Contemporary
Art, Los Angeles, 16 February – 18 May 1997; Tate Britain 12 June – 7 September
1997 and the Haus der Kunst, Munich, November 1997 – January 1998.

Orange Red Relief 1959, Oil on canvas, two joined panels, 152.4 x 152.4 x 7.6 cm
Collection of The Solomon R. Guggenheim Museum, New York

Pony 1959, Painted aluminium, 78.7 x 198.1 x 162.6 cm, Collection Miles and Shirley Fiterman

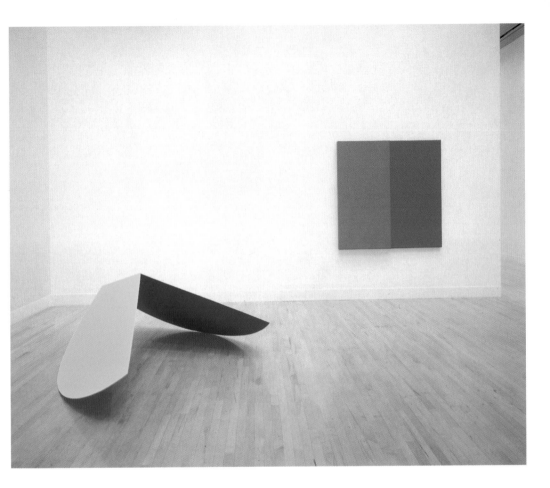

Introduction

Susan Daniel–McElroy

Since the late 1940s the American artist Ellsworth Kelly has used the day to day flow of elusive forms seen in his life as a way of progressing his exploration into pure abstraction with colour. Reducing and repeating sections of things in miniature, or views through doorways, windows, clothing, foliage or shadows falling across structures, gave Kelly the raw material to establish new illusions of space and colour. His paintings and sculpture reveal his extraordinary poetic vision and sense of geometric clarity, but the apparent simplicity of his art is dangerously deceptive. Kelly has been devoted to a life-long quest for abstraction on his own terms, perhaps believing, like Piet Mondrian, that simplicity is the ideal state for humankind.

Kelly's skill in working with form, colour, space and edge to create potent visual statements, results from his acute spatial sensibility and experience in fusing these elements. Kelly treats colour as an independent element. Representation no longer plays a role but colour itself becomes form; a kind of sculpture of colour if you like, in which the architectural plane or wall upon which the painted object sits, and the volume of space around it, becomes part of the work.

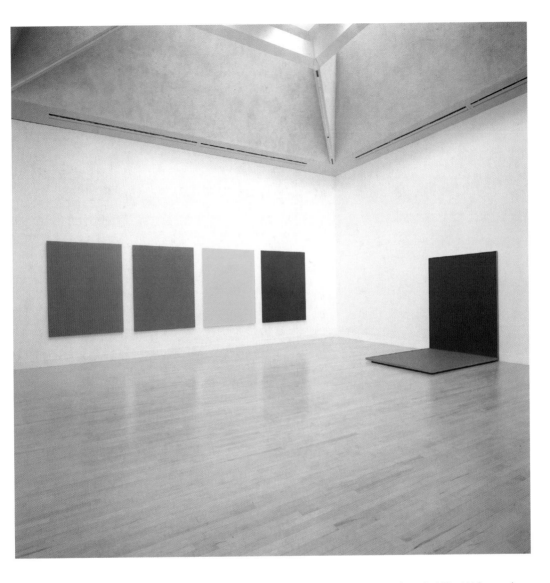

Green Red Yellow Blue 1965, Acrylic on canvas, four separated panels, 193 x 144.8 cm each
193 x 647.7 cm overall, spaced 22.9 cm apart, Collection Irma and Norman Braman

Blue Red 1966, Acrylic on canvas, two joined panels, 205.7 x 152.4 x 205.7 cm
San Francisco Museum of Modern Art and anonymous co-owners

Green Angle 1970, Oil on canvas, 177.8 x 586.7 cm, The Eli and Edythe L. Broad Collection, Los Angeles
Black Square with Blue 1970, Oil on canvas, two joined panels, 304.8 x 304.8 cm, Tate

Kelly is no Minimalist but an artist who paints in series and who thinks in themes rather than individual motifs. He restricted himself initially to what appeared to be primary colour – red, blue and yellow and the black that can be made from them – and explored the repetition of forms in contrast with each other, creating visual tension through these extraordinary juxtapositions.

His approach is a continuous and meticulous refinement of his vocabulary of shapes and colour relationships. He has an unusual sense of perspective – see *Yellow Curve* (1996) for example or *Broadway* (1958), and a fascination with subverting the painting's edge and picture plane. Kelly often plays with relationships such as light and shadow and the painting's edge as the joining and separation of areas. Uniquely, he has made the act of seeing itself the central subject of his work.

As always there are many individuals who have played important roles in the shaping of this exhibition. Mary Bustin and Katharine Lockett, Tate's conservation curators, Kate Parsons and Bronwen Gardner, Tate's registrars and the Tate St Ives team, particularly Norman Pollard, Arwen Fitch, Matthew McDonald and Sara Hughes.

In Ellsworth Kelly's studio, we are grateful to Sandi Knakal and Eva Walters and in particular, Jack Shear, Director of the Ellsworth Kelly Foundation. We are particularly thankful to Tate St Ives members – especially our outgoing Chair David Falconer – who have supported this important exhibition and the making of this publication. We are also indebted to the lenders who have contributed their valuable works to the exhibition so generously.

Our warm appreciation to Christoph Grunenberg – Director of Tate Liverpool – who has written a striking essay on Tate's collection works by Ellsworth Kelly. His text creates new insights into Tate's beautiful holdings of paintings, sculpture and works on paper. Lastly, I would like to thank Ellsworth Kelly for making this show for us, it has been enriching for all involved in the shaping of it to work with him.

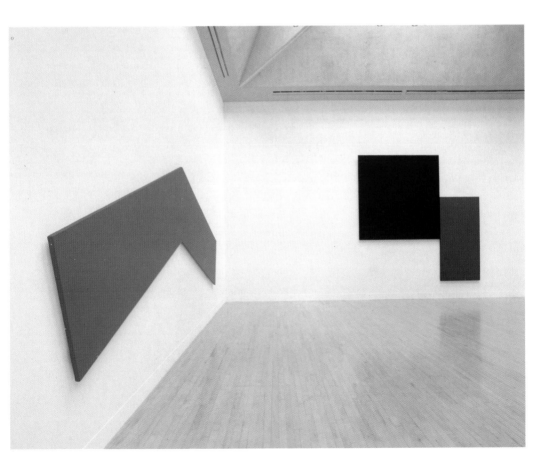

'the form of my painting is the content'

Two Blacks and White 1993, Oil on canvas, three joined panels, 195.6 x 400.1 cm, Private collection

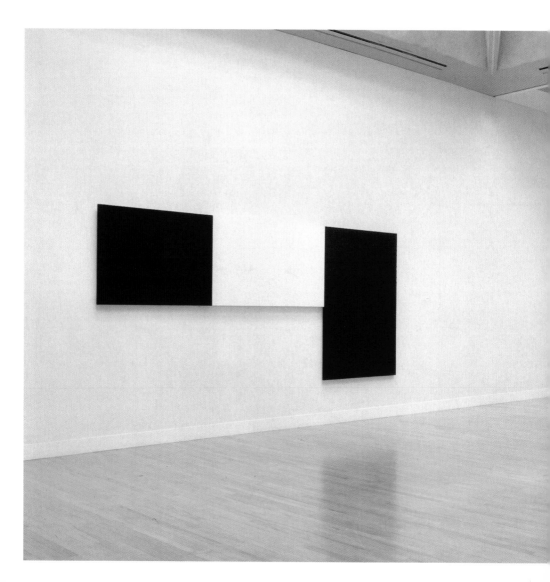

Orange Red Relief (for Delphine Seyrig) 1990, Oil on canvas, two joined panels, 305.4 x 250.2 cm
Museo Nacional Centro de Arte Reina Sofia, Madrid

Untitled 1988, Bronze, 304.8 x 62.2 x 2.5 cm, National Gallery of Art, Washington D.C.

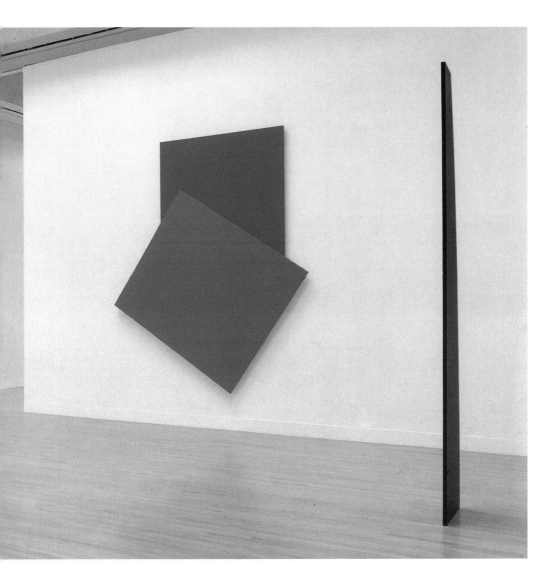

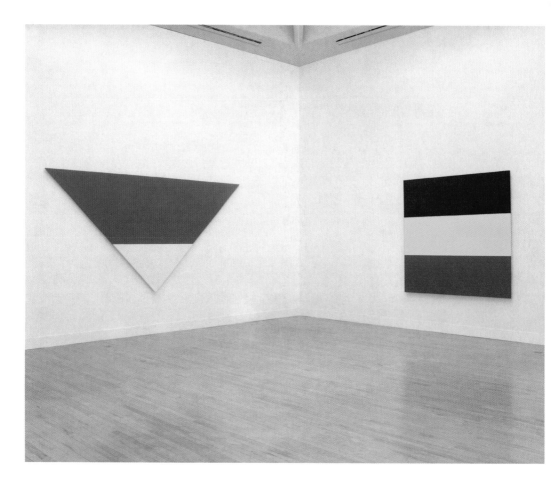

Green White 1968, Oil on linen, two joined panels, 180.3 x 358.1 cm, Private collection
Blue Yellow Red III 1971, Oil on canvas, three joined panels, 182.9 x 188 cm, Collection of Jack Shear

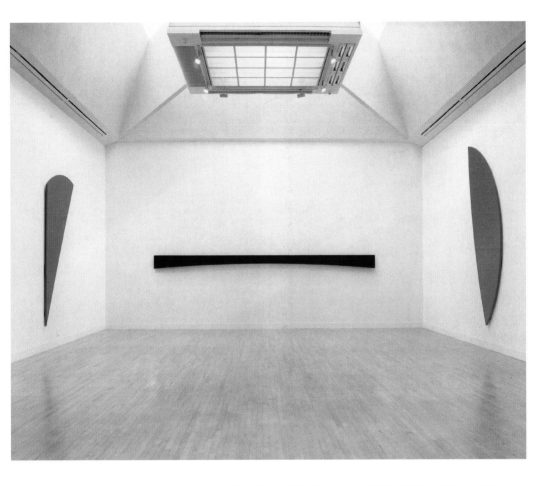

Green Curve 1996, Oil on canvas, 302.3 x 164.5 cm, Private collection
Horizontal Curve I 1996, Bronze, 34.9 x 609.6 x 3.2 cm, Private collection
Red Curves 1996, Oil on canvas, 360.7 x 166.4 cm, Private collection

Plant II 1949, Oil on wood, 41.9 x 33 cm, Private collection
Yellow Curve 1996, Oil on canvas, 135.7 x 355.6 x 3.2 cm, Tate

Modern Icons: The Contradictions of Ellsworth Kelly

Christoph Grunenberg

Artistic exploration tends to defy the convenience of stylistic coherence and assumed thrust of teleological linearity. Detours, apparent incongruities and the seeming surf and swell of artistic prowess are an inevitable part of any artistic career. Ellsworth Kelly has occupied a somewhat ambiguous position in contemporary critical reception and in the art histories charting the past half century. He never fully fitted into any of the quick successions of stylistic labels – whether Post-Painterly Abstraction, Colour Field and Hard Edge painting or Minimalist Art, pursuing a deeply individual, at times solitary path. Kelly is exemplary in his unitary devotion to the progress of his life-long quest for an original abstraction. It has resulted in a complex, multi-layered body of work that has resisted easy stylistic categorisation and thrives on the inherent paradoxes that characterise all great art.

Despite his devotion to abstraction and a self-imposed limitation in expressive means, an oeuvre emerges that is by no means monolithic but full of productive tensions and contradictions. He has approached painting with a penchant for formal and material purity that nevertheless resulted in lyrical abstractions of great evocative force and sensual immediacy. Despite the uncompromising

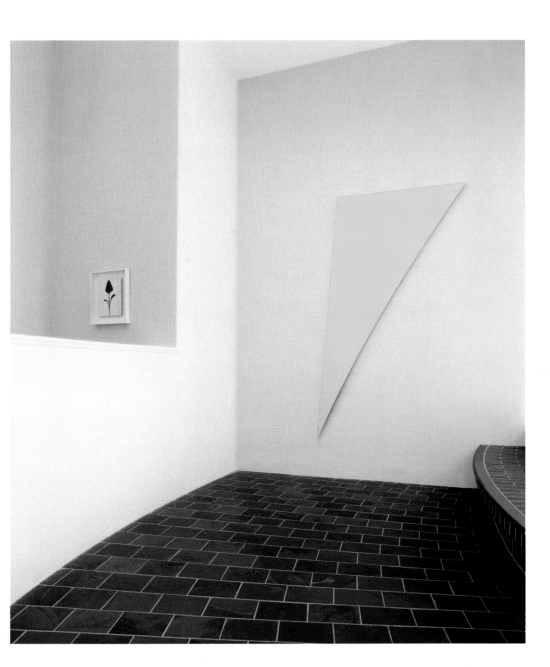

geometry and hard-edge definition of form and the purging of his surfaces of all gestural expression, his paintings and sculptures are 'expressive' in that they evoke strong emotional responses from the viewer. He has remained a painter's painter with an acute sense for the materiality of his medium and the intense effects that can occur on a surface. In producing these responses Kelly relied less on the force of the 'sublime', which enjoyed much currency in the immediate post-war decades as both artistic prerogative and critical term, than on effects which might be defined closer to Kant's original definition of 'natural beauty'. Similarly, an almost puritanical appreciation of the beauty, simplicity and economy of means found in the products of anonymous craftsmen from prehistoric people to the Shakers coexists with a deep affinity for the *élan vital* and *joie de vivre* found in Mediterranean cultures. He has produced an art that is at once 'classical' in its compositional severity and emphatic clarity while avoiding the apathetic force of the rectilinear and the restrictive authority of the symmetrical. While Kelly's art fulfils many of the principles of formalism, he also has created works that directly challenge the critical dictum of medium-specificity, material honesty and non-hierarchical internal composition. In particular, he has combined painting and sculpture into a new hybrid medium, possibly best described as 'painterly relief' which plays a central role in his art. Finally, the traditional opposition of nature versus abstraction, representation versus non-objectiveness never has been an issue to him. Abstract paintings and exquisite linear plant drawings have coexisted and, on occasion, fed off each other, the artist oscillating between manifestly emblematic abstraction and strictly formalised nature. The inspiration for his simple compositions of geometric shapes in bold colours ultimately always have been derived from nature and perceptual impressions rather than being based on the translation of abstract or universal concepts into visual imagery.

Kelly belongs to a generation of artists to whom a non-objective visual language was not yet available as a natural starting point but had to be conquered in a slow progress from concrete to abstract imagery. Through a process of trial and experimentation, Kelly developed an expanding arsenal of compositional

tools that assisted him in the distancing process from the visible world and the translation of perceptual stimulus into powerful abstract works. These included, at different stages of his career: automatic drawing and chance; the use of photography, collage, shadows and silhouette as inventing and abstracting mechanisms; the transcendence of the traditional picture format and introduction of shaped canvases; the rejection of relational composition in favour of a bold monochromatic frontality as a means to achieve disassociating flatness; and, finally, a consistent play with figure-ground relationships that transcend the perimeters of the canvas. Conquering these techniques of abstraction involved radical breaks and shifts against the prevailing mode of gestural abstraction and inspiration from unlikely sources ranging form ancient art to encounters with John Cage in 1950s Paris. Kelly saw his art grow from a hybrid genealogy: 'My work is about structure… My line of influence has been the 'structure' of things I liked: French Romanesque architecture, Byzantine, Egyptian and Oriental art, Van Gogh, Cézanne, Monet, Klee, Picasso, Beckmann. … Brancusi, Vantangerloo, Arp, and Sophie Taeuber-Arp.'[1]

The ambiguous and somewhat fluid position occupied by Kelly in contemporary critical discourse can be traced to the artist's early nomadic existence that followed a path reverse to most of his compatriots and contemporaries, confounded by the unfolding geo–political rivalry between the so-called Old and New Worlds, which was partly contested on artistic territory. Kelly operated directly in the fault lines of this battle for cultural hegemony, studying in Boston before experiencing firsthand what it meant to be an American in Paris, feeding on the rich cultural heritage of millennia but also on the ever-present residue in all aspects of daily life of this ostensibly most sophisticated of cultures. In some ways, Kelly never fully belonged, first venturing as eager student from a supposedly artistically backward country to the cradle of modern art to learn from the great masters.[2] 'When I got to Paris, I felt like – what am I doing here?' Kelly remembered. 'What am I going to be? A tenth-rate Picasso? And I said, I'm not European. I am not steeped in the European tradition of painting. I was attracted to Picasso like all the painters were in those days. That was the thing

Broadway 1958, Oil on canvas, 198.1 x 176.8 cm, Tate

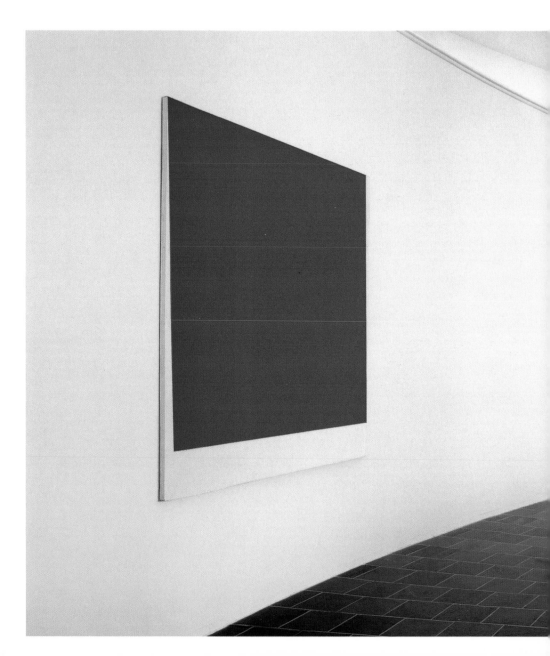

Black Square with Blue 1970, Oil on canvas, two joined panels, 304.8 x 304.8 cm, Tate
Orange Relief with Green 1991, Oil on canvas, 237.5 x 215.3 cm, Tate

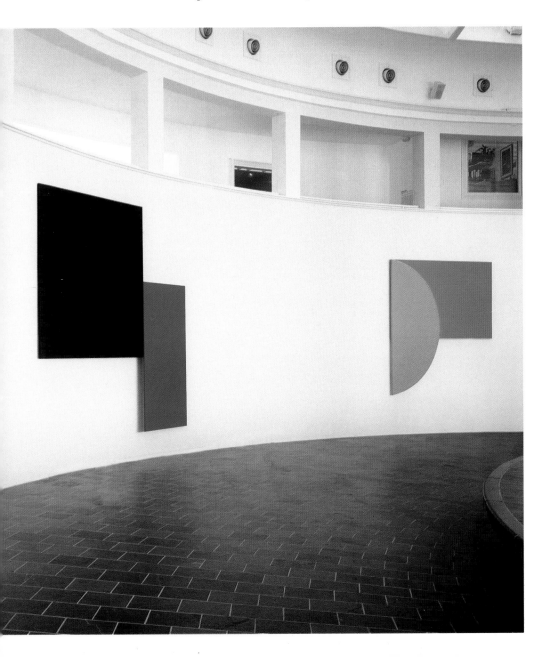

Black Square with Blue 1970, Oil on canvas, two joined panels, 304.8 x 304.8 cm, Tate
Orange Relief with Green 1991, Oil on canvas, 237.5 x 215.3 cm, Tate

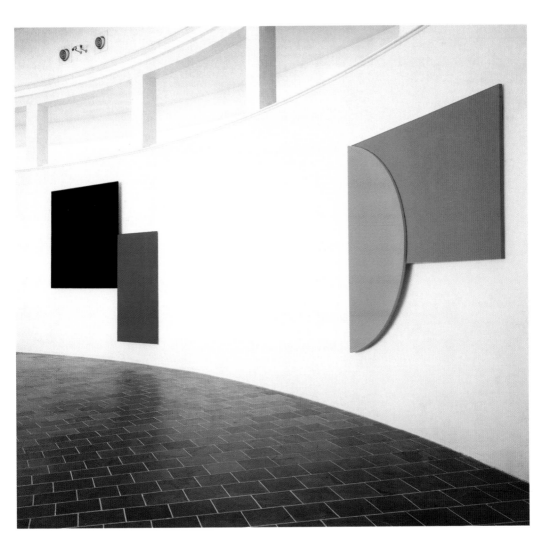

to fight against, I suppose. So then I got very depressed about that and thought, maybe I'm not an artist. I'm American.'[3] Even though not recognised at the time, he introduced an artistic revolution into the heart of civilisation which, by that time, already showed signs of exhaustion under the pressure of adverse circumstances.

Unlike many of his fellow artists of the immediately preceding generation of the Abstract Expressionists, he did not strive to overcome the European avant-garde by defying it both as a creative model and destination but returned to Paris in 1948 to study and paint. There he was faced with the challenge of how to develop an authentic abstract language in the wake of the heroic period of modernism with its extremes of the uncompromising reductivism of Malevich and Mondrian and the inexhaustible formal inventiveness of the giants Picasso and Matisse. Kelly built on the achievements of these and other artists while, at the same time, transcending their example. The desperate search for abstraction during his sojourn in France involved reducing structures in nature or the man-made world to abstract patterns, discovering ready-made compositions in the shadow configurations thrown by metal staircases, on exposed building facades, in the shimmering plus and minus of the sun reflected in the sea and in the figure-ground interaction of plants and flowers. Matisse provided the intensity of vibrant colour cadences and liberation from the strict geometry of the more hardened Northern abstractionists. Additional compositional tools were provided by Jean Arp and the Dadaists through the elements of chance while Joan Miró, Paul Klee and Alexander Calder offered the liberating force of poetic playfulness and biomorphic abstraction.

For Kelly the breakthrough came in the late 1940s and early '50s, with his first multi-panel and colour spectrum paintings. In these works he abandoned self-conscious, internal pictorial composition for a combination of unstructured monochrome panels as in the ground-breaking *Painting for a White Wall* (1952). *Méditerranée* of the same year is his first 'painterly relief' – as opposed to the earlier sculpted 'totemic' wood reliefs of the late 1940s and the 'constructed reliefs', such as *Window, Museum of Modern Art, Paris* (1949). *Méditerranée* is an important step in his evolution as 'composition' is reduced to a dynamic

juxtaposition of nine, equal-sized rectangles in five colours including black and white. Hans Hofmann's notorious 'push and pull' of rectangles in varied colour values and scale has been organised into an uncompromising modular grid that does away with painterly definition and creates depth predominantly through the actual spatial layering of discrete canvases supported by colour perspective. The title clearly points to the Mediterranean Sea as inspiration for this apparently non-objective work. Geometric abstraction here allows the communication of an impression that transcends pure visual perception – the pulsating colours of the South, the midday summer heat, the glittering of the waves and sun reflected in the water, the simplicity of architecture and fashions. It is a new mode of abstraction that is neither abstracted from nature nor a purely formal and non-objective composition but, through its title, evokes a culture and its correlated sensual impressions and memories.

Another example of how title and image work together in triggering certain associations and thus produce meaning can be found in the painting Broadway, the earliest work in the Tate Collection dating from 1958.[4] A bold cadmium red parallelogram inscribed on a white rectangle with extremely sharp edges pointing in opposite directions produces an uneasy tension between figure and frame that is characteristic of the period. The skyscraper canyons, the irregular winding of the 'Great White Way' through the rigid grid of Manhattan, the brilliant pulse of illuminated theatre signs and advertisements on Times Square are all encapsulated in the minimally elongated, asymmetrical shape of a distorted rectangle on a dazzling white field. Colour, form and ground work together with the associations evoked by the title. As Kelly has pointed out, the title was also chosen because of its implication of space, as in the original meaning of 'broad way'.[5] And with minimal gaps left between the vertical sides of the red shape and the frame, the red figure can indeed be read as a passage. Broadway started its life as a 'study' for a painting entitled Wall (1956) in which the leaning rectangle is black, as so often in the initial testing out of compositions. Kelly has spoken of his working method as a process of addition rather than abstraction and colour plays a critical element in this:

'… my paintings are about beginning something rather than starting with a lot and throwing some of it out. I start with a form and then I add to that. … A lot of ideas start in black and white.'[6] A counterpart to *Broadway* from the following year employs an almost identical composition. The main difference in *North River* (1959) is that the parallelogram is rendered in a uniform medium blue. Other subtle differences include the less extreme inscription into the ground and the almost even format of the blue shape. The red hot skyscraper canyon has turned into a cool ravine and we have moved form the urban jungle to untamed nature, effected by a change of colour and the subtle adjustment of a limited number of compositional details.

Titles are critical in Kelly's paintings, re-establishing the connection to the visible world as they trigger a string of multiple associations and connotations that establish significance. In the modernist canon, illustrative titles are frowned upon and are only tolerated as a confirmation of the absence of representational subject matter ('Untitled'), in purely descriptive terms ('Orange-Brown') or as ordering device ('Number One' etc.).[7] For Kelly, at this time, titles functioned as an integral compositional means through which the indeterminate, respectively predominantly literal nature of an abstraction (red parallelogram surface painted on white rectangular canvas) could be made specific. The 'open situation', as Kelly once described his paintings, is approximated to a poetic evocation of a specific place in a particular city.[8] On occasion, titles have also hinted at the transcontinental transfer of traditions and meanings between Europe and America, most pronounced in language. Two early reliefs of 1950, *Saint Louis I* and *II*, allude not to the Mid-Western city but to the Rue Saint-Louis-en-l'Ile in Paris, Kelly combining an indexical representation of a structured wall with a verbal pun. Different taxonomic conventions can also translate into an abstracting and alienating device as, for example, in the 1949 painting of the ubiquitous kilometre marker whose shape is, of course, unfamiliar outside France.

In 1991 Kelly observed that 'I am beginning to feel that all my paintings are really reliefs… They are like objects on the wall.'[9] The relief as a modus operandi is at the core of Kelly's investigation into abstraction as an expressive medium.

Some of the artist's earliest breakthrough works were made through the medium of the relief and the technique appears at regular intervals.[10] Relief is a hybrid technique and highly ambiguous mode of expression – strictly a form of sculpture that plays with the two-dimensionality of painting's pictorial space. It has served as a means to venture into a territory in which a work can still function as 'painting' yet also transcends the medium and its inherent limitations. The relief can be a highly dynamic form as corporal figures emerge from a flat background into space or, in the form of a frieze, create horizontal and vertical narrative flow. In the seminal *Window, Museum of Modern Art, Paris* (1949) Kelly presents a radical denial of illusionism and the reduction of his artistic means to essential properties of flattened shapes and non-colour. At the same time, this relief reveals itself also as a readymade in as much it clearly is a found subject constructed out of ordinary and identifiable materials – wood, canvas and paint. Kelly considered *Window* his '… first object… From then on, painting as I had known it was finished for me. The new works were to be painting/objects, unsigned, anonymous. Everywhere I looked, everything I saw became something to be made, and it had to be made exactly as it was, with nothing added. It was a new freedom: there was no longer the need to compose.'[11] Kelly takes the century-old topos of painting as a vista out of a window into the real world and reverses it, the blind exterior of *Window* stopping the gaze short. It is not insignificant that the roaming eye of the artist happened to fall onto the window of a modern art museum, the home of many (abstracted) views, scenes, landscapes and panoramas, announcing a paradigm shift from mimetic representation to a different mode of rendering of visual and sensual impressions on a new kind of representational plane.

While there are examples of wall-based works penetrating space (in particular in the collages of Jasper Johns and Robert Rauschenberg), the relief had no real place in American art of the 1950s and by the mid '60s was violently rejected by the Minimalists as an outmoded and almost frivolously wasteful technique. In the early 1950s, Clement Greenberg had noticed that the 'connection of sculpture and painting is closer today than for a long time in the past, but is not

entirely new.'¹² However, what Greenberg here was mainly alluding to is the occasional approximation between painting and sculpture as it can be found, for example, in the pictorial flatness employed in some sculptures by David Smith and Anthony Caro. The bas-relief is only an intermediary step from collage to non-objective sculpture which, in an attempt to rid itself from the association with the body and organic shapes, favours pictorial flatness: 'It is significant… that modernist sensibility, though it rejects sculptural painting of any kind, allows sculpture to be as pictorial as it pleases. Here the prohibition against one art's entering the domain of another is suspended, thanks to the unique concreteness and literalness of sculpture's medium.'¹³ This liberty, as Greenberg makes clear, does not apply to 'painterly sculpture'. Robert Morris categorically rejected the relief, stating that 'it cannot be accepted today as legitimate. The autonomous and literal nature of the sculpture demands that it have its own, equally literal space – not a surface shared with painting. Furthermore, an object hung on the wall does not confront gravity; it timidly resists it.'¹⁴ Similar, the use of 'unnatural' colour in sculpture was an anathema to the strict Minimalists codex (which, in many ways, presented a considerable toughening of Formalist principles), distracting from its essential purpose of rendering physical objects in space. Again, Morris objected to the violation of the fundamental material properties of the medium, condemning its use in strongly moralistic terms, as 'it is this essentially optical, immaterial, non-containable, non-tactile nature of colour that is inconsistent with the physical nature of colour.'¹⁵

From *Méditerranée* onwards, multipanel paintings and reliefs are a constant in Kelly's work as he meticulously exercises the unexpected dramatic potentials of this pictorial convention. The two-panel painting *Black Square with Blue* (1970) sets an elevated black square against a smaller blue rectangle, its upper edge fixed exactly in the centre of its right perimeter. The two monochrome canvases operate on the same vertical plane but are clearly distinguished as individual parts through the evident rift between the adjoining stretchers. The continuity of the picture plane is ruptured providing an opportunity for Kelly to dissect a work of art into its constituent elements but also extend its impact beyond the

steel, positioned at some distance from and parallel to the wall, is best experienced frontally like a painting. It can also be circumnavigated, destroying any residues of the illusion of a virtual pictorial space, revealing the sculpture as a solid, one and a quarter inch thick sheet fixed to the ground by an angular base invisible from the front. In this blurring between sculptural and painterly properties, *Curve XXXI* again strongly parallels the relief with its frontal orientation, the beholder assuming 'a parallel omniscience in his reading of the work in all its lucidity'.[24]

Ellsworth Kelly's quest for abstraction resulted in an art of bold elegance and moving subtlety that balances effortless directness with an intriguing ambiguity, non-representational abstraction with residues of concrete imagery, anonymous form and execution with a highly distinctive and recognisable language, and grand monumentality with human scale. Kelly's work as a whole is united by its clearly defined gestalt image, its bold frontality, its spatial ambiguity and its projection into the space of the beholder. It is penetrated by a desire to rise above the limits of communication posed by traditional easel painting through an aggressive and uncompromising directness. In all his work, from his early portraits to the erotic plant paintings, full-frontal abstract paintings and free-standing sculptures, Kelly searched for a compelling language that produces a robust emotional reaction. The early reliefs, for example, can be read as primitive masks and totems that seem to search for a symbolic mode of expression that has the religious immediacy of cultic and devotional objects. Kelly frequently referred to his early fascination with Byzantine art and Romanesque frescos. These are uncompromisingly frontal, often confrontational, images with God and saints directly focussing onto the worshipper, their heavy delineation giving them an almost sculptural quality that is reflected in Kelly's portraits of the late 40s. He further expressed the ambition to create an art that had an impact similar to that of the Pre-Renaissance in its intensity of contact and effect. In 1950 he called for paintings to be presented 'outside as billboards or a kind of modern 'icon'. We must make our art like the Egyptians, the Chinese & the Africans & Island primitives – with their relation to life. It must meet the eye – direct.'[25]

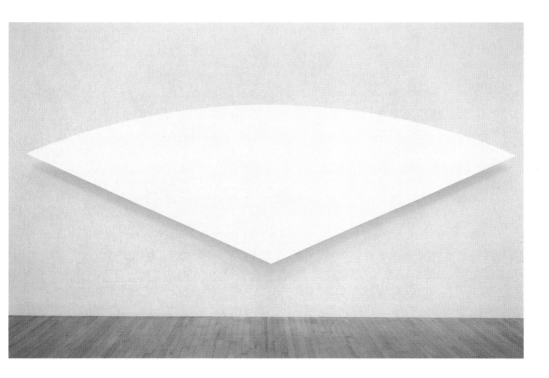

Blue Ripe 1959, Oil on canvas, 237.5 x 215.3 cm, Caldic Collectie B.V.

Kelly's art thus might be best described as 'iconic' – both in the traditional sense of pre-modern religious painting and idols to be worshiped and the semiotic construct of the 'iconic sign' – 'a sign that stands for its object mainly by resembling or sharing some features (e.g. shape) with it; such a resemblance having a status called iconicity.'[26] 'Iconic' signs are those signs that are 'part of a well-entrenched or familiar language', being both easily identifiable and carrying a clear message.[27] However, in order for a sign to be iconic, it needs to go beyond the familiarity of pure recognition and establish a more complex relationship between the sign and referent, which presents the work as both effectively simple in its communicating form and inherently complex in the meanings it conveys.[28] The expansive sweep of *White Curve* (1974) is a good example of how a work can both allude to a specific place (a snow covered hill in New York State) and also constitute an almost diagrammatic representation of a common type of landscape configuration. Richard Wollheim has described how visual conventions assist in the perceptual process to 'read off the profile of the hill from the contour lines, just because these methods are so tangential to the processes by which we ordinarily acquire and distribute knowledge.'[29] Kelly's compelling iconic imagery and intense colour effects are elemental in their impact while simultaneously being embedded in the visual vernacular of post-war America, evoking as much the curve of a hill or the shadow play of a plant as the aesthetics of 'cool' of corporate logos and advertising. They are highly condensed images that function as generalised references to the phenomenal world as well as non-referential signs appealing to distant, shared recollections and an innate aesthetic sense: 'As a deep explanation we might want to correlate the seeing of a sign as iconic with a regression to the 'concrete thinking' of earliest infancy.'[30] Kelly's oblique references to nature go beyond the direct abstraction of visual forms and present a wider sensual repertoire of memories, impressions and sensations. Like all the best of abstract art, they derive their power to move the beholder from what traditionally would have been called elements of 'beauty' – the sensitive balancing of a reduced vocabulary of form, scale and colour to create a presence that is both immediate and universal.

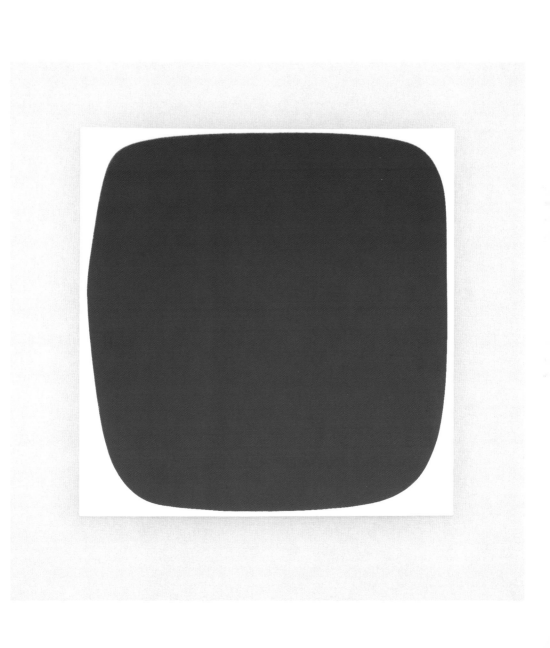

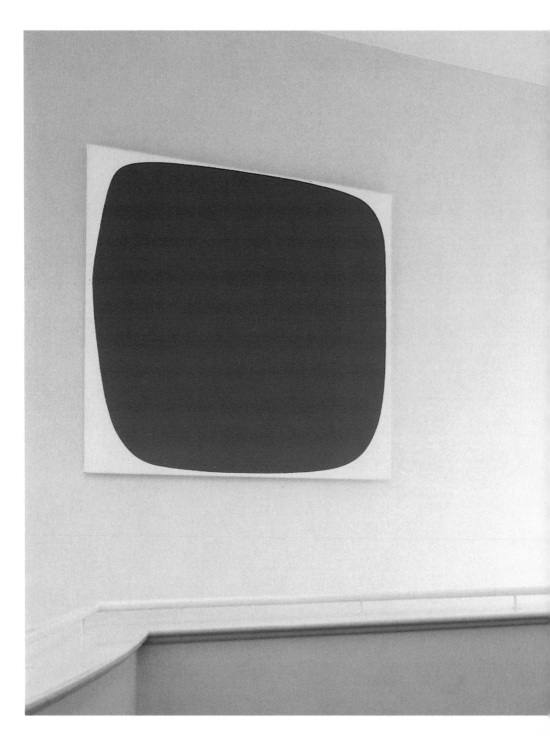

'my work is about structure…

my line of influence has been the structure of things'

Below **Plant II** 1949, Oil on wood, 41.9 x 33 cm, Private collection
Opposite **Plant I** 1949, Oil on canvas, 35.6 x 27.9 cm, Kröller-Müller Museum, Otterlo

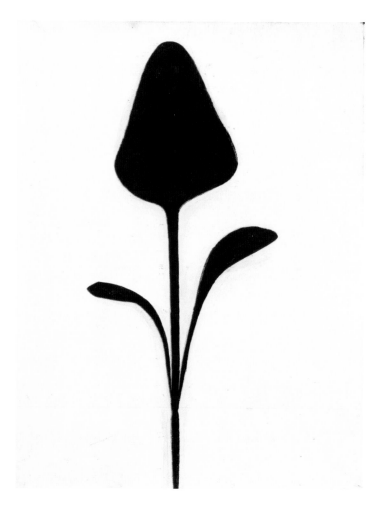

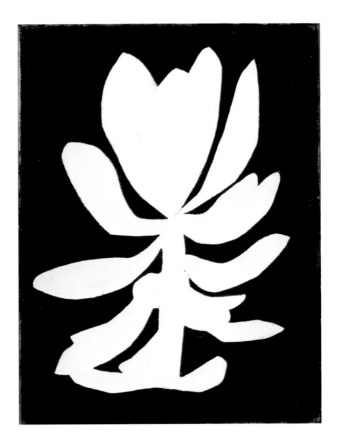

Orange Relief with Green 1991, Oil on canvas, 237.5 x 215.3 cm, Tate

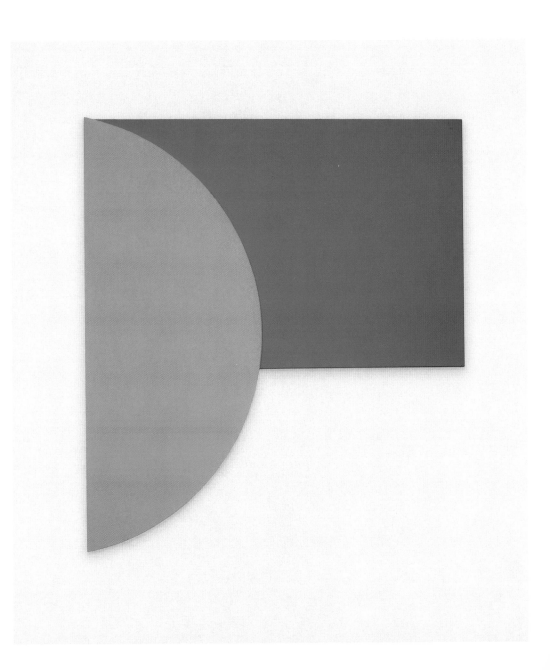

Red/Blue (Untitled) 1964, Screenprint on Mohawk Superfine Cover paper, 61 x 50.8 cm

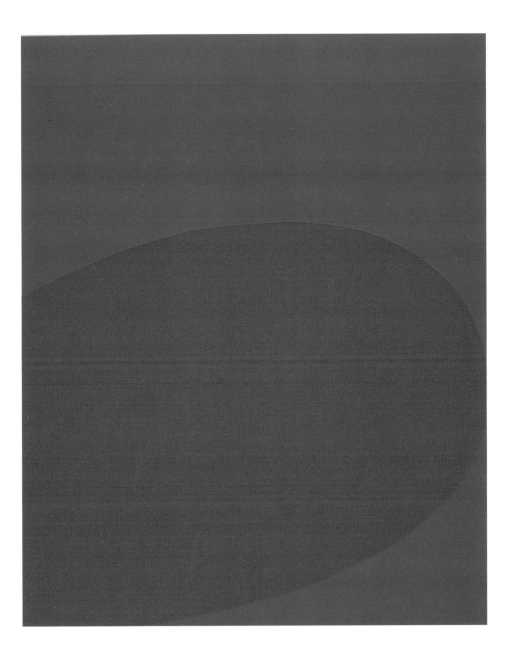

Nine Squares 1976–7, Screenprint and lithograph on Rives BFK paper, 102.9 x 102.9 cm

Below **Concorde II (State)** 1981–2, Etching and aquatint with plate tone on Arches Cover paper, 83.2 x 63.8 cm

Opposite **Concorde IV (State)** 1981–2, Etching and aquatint with plate tone on Arches Cover paper, 87.6 x 65.7 cm

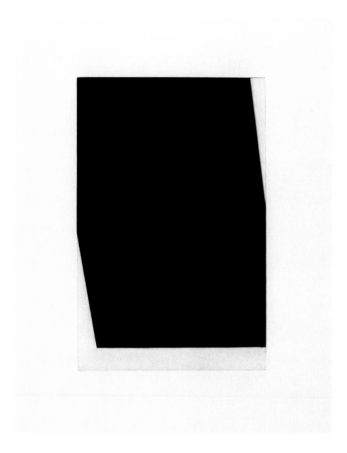

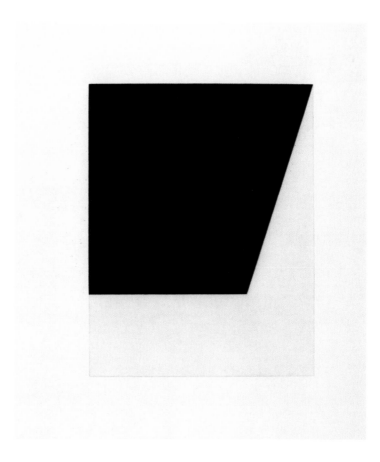

Diagonal with Black (State) 1981–2, Etching and aquatint with plate tone on Arches Cover paper, 86.7 x 74 cm

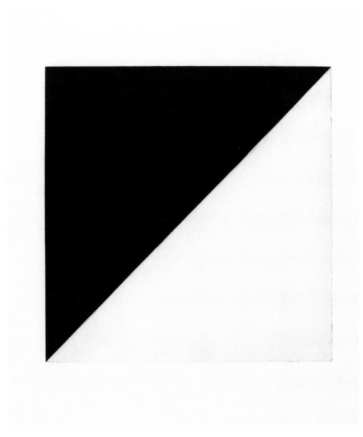

The Mallarmé Suite 1992, Four lithographs on Rives BFK paper, Each sheet: 73.7 x 54.6 cm

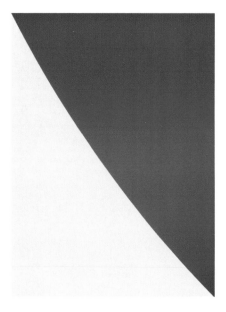 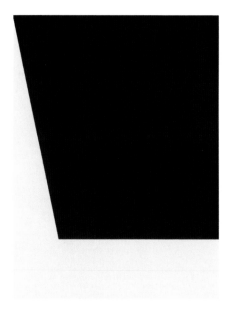

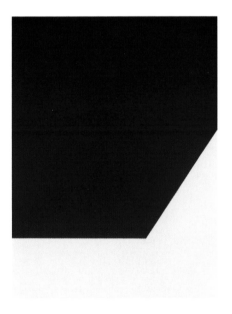

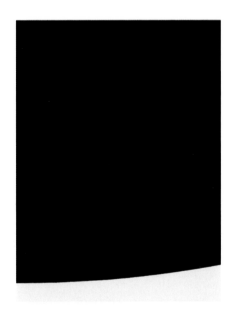

'everywhere I looked, everything I saw became something to be made, and it had to be made exactly as it was, with nothing added'

Notes

1 'Notes from 1969' in *Ellsworth Kelly: Paintings and Sculpture 1963–1979*. Stedelijk Museum, Amsterdam, 1979, p.32.

2 In this respect Kelly combines aspects of two artistic 'types' operating in different kinds of creative milieus, as defined by George Kubler: 'The genuine precursor usually appears upon the scene of a provincial civilisation, where people have long been the recipient rather than the originators of new behaviour. The rebel like Picasso finds his situation at the heart of an old metropolitan civilisation.' *The Shape of Time: Remarks on the History of Things*. New Haven, Connecticut and London: Yale University Press, 1962, p.91.

3 'Interview: Ellsworth Kelly Talks with Paul Cummings', *Drawing*, vol. 13, no. 3, September–October 1991, p.57.

4 Kelly has described the production of this substantial canvas: 'I painted in Agnes Martin's studio. We lived in two different buildings with the same staircase and I was on the top floor and I couldn't get the stretcher up to my studio. So I said, Agnes go take a week off, I am going to paint this in your studio.' Jo Crook and Tom Lerner, 'Unpublished Interview with Ellsworth Kelly' Tate Gallery, London, 9 June 1997.

5 Jennifer Mundy, ed., *Brancusi to Beuys: Works from the Ted Power Collection*. London: Tate Gallery Publishing, 1996. p.40. Other examples of paintings named after specific locations or buildings in New York are Brooklyn Bridge, Manhattan and Wall, all dating from 1958.

6 'Ellsworth Kelly Talks with Paul Cummings', p.61.

7 There are, of course, numerous examples where this rule has been broken and abstract and non-objective works have been furnished with descriptive, mythical and even hyperbolic titles in an attempt to escape purely literal interpretations. See in particular Anna C. Chave, 'Minimalism and the Rhetoric of Power', *Arts Magazine*, vol. 64, no. 5, January 1990, pp.44–63.

8 'Ellsworth Kelly Talks with Paul Cummings', p.61.

9 'Ellsworth Kelly Talks with Paul Cummings', p.58.

10 Of his early reliefs Kelly himself has said: 'They weren't paintings; they were somewhere between painting and sculpture.' 'Ellsworth Kelly Talks with Paul Cummings', p.58.

11 Quoted in John Coplans, *Ellsworth Kelly*. New York: Harry N. Abrams, 1971, p.28.

12 'Cross-Breeding of Modern Sculpture' in *Clement Greenberg: The Collected Essays and Criticism. Affirmations and Refusals, 1950–1956*. Edited by John O'Brien. Chicago and London: University of Chicago Press, volume 3, p.107.

13 Clement Greenberg, 'The New Sculpture', in Idem., *Art and Culture: Critical Essays*. Boston: Beacon Press 1965, p.143. See also 'The New Sculpture', in *Clement Greenberg: The Collected Essays and Criticism. Arrogant Purpose, 1945–1949*. Edited by John O'Brien. Chicago and London: University of Chicago Press, volume 2, p.317.

14 'Notes on Sculpture', in Gregory Battcock (ed.), *Minimal Art: A Critical Anthology*. New York: E. P. Dutton & Co., 1968, p.224.

15 'Notes on Sculpture', p.225.

16 Rosalind E. Krauss, *Passages in Modern Sculpture*. Cambridge, Massachusetts and London: MIT Press, 1981, pp.20–21.

17 Rosalind E. Krauss, *The Originality of the Avant-Garde and other Modernist Myths*. Cambridge, Massachusetts and London: MIT Press, 1986, p.216. About the multipanel and relief works see also Roberta Bernstein, 'Ellsworth Kelly's Multipanel Paintings', in Diane Waldman, ed., *Ellsworth Kelly: A Retrospective*. Guggenheim Museum, New York 1996, pp.40–55; Sarah Rich, 'Attention! Ellsworth Kelly's Reliefs', in *Ellsworth Kelly: Relief Paintings, 1954–2001*. Matthew Marks Gallery, New York 2001, pp.16–29; Gottfried Boehm, 'In-Between Space: Painting, Relief and Sculpture in the Work of Ellsworth Kelly',

in *Ellsworth Kelly: In-Between Spaces, Works 1956–2002*. Fondation Beyeler, Riehen/Basel, 2002, pp.16–45.

18 Letter by Ellsworth Kelly to John Cage, 4 September 1950. Quoted in Jack Cowart, 'Method and Motif: Ellsworth Kelly's 'Chance' Grids and His Development of Color Panel Painting, 1948–1951', *Ellsworth Kelly: The Years in France, 1948–1954*. National Gallery of Art, Washington, D.C. 1992, p.41.

19 The most prominent one being without doubt the almost 20 metre long relief sculpture for the Transportation Building, Penn Center in Philadelphia. Other notable examples include the Houston Triptych on the outside of the Museum of Fine Arts in Houston, 1986; and the site-specific work for the Federal Courthouse, Boston, 1988.

20 'Notes on Sculpture', in *Ellsworth Kelly: In-Between Spaces, Works 1956–2002*. Fondation Beyeler, Riehen/Basel, 2002, p.47.

21 Immanuel Kant, *The Critique of Pure Reason*. Translated by James Creed Meredith. Oxford: Clarendon Press, 1952, p.90.

22 Kelly, 'Notes from 1969', p.32.

23 'I am a painter, making paintings!' Kelly once emphatically stated when asked about his relationship to sculpture. Ann Hindry, 'Conversation with Ellsworth Kelly', *Artstudio*, vol. 24, Spring 1992, p.24.

24 Krauss, *Passages in Modern Sculpture*, p.14.

25 Letter by Ellsworth Kelly to John Cage, *Ellsworth Kelly: The Years in France, 1948–1954*, p.41 (emphasis added).

26 Chris Baldick, *The Concise Oxford Dictionary of Literary Terms*. Oxford and New York: Oxford University Press, 1990, p.105. 'Icon' was defined by Charles Sanders Peirce who identified three classes of signs: symbol, index and icon. The icon 'may represent its object mainly by similarity,' 'directly communicating an idea'. *Collected Papers of Charles Sanders Peirce. Volume II, Elements of Logic*.

Edited by Charles Hartshorne and Paul Weiss. Cambridge, Massachusetts: Harvard University Press, 1932, pp.157–158. Kelly's work has previously been related to 'the index' referencing, in particular, the actual physical marks of the early carved and string reliefs. See Yve-Alain Bois, 'Ellsworth Kelly in France: Anti-Composition in Its Many Guises', in *Years in Paris*, pp.17–22.

27 Richard Wollheim, *Art and Its Objects*. Harmondsworth: Penguin, 1968, p.137.

28 '...once we have seen the sign as iconic we then tend to disguise this by talking as though there were just one special property of 'the sign, that of being iconic, of which we had now become aware. We think that the sign is tied to its referent by one special link, whereas in point of fact there are merely many associations.' Wollheim, *Art and Its Objects*, p.139.

29 Wollheim, *Art and Its Objects*, p.137.

30 Wollheim, *Art and Its Objects*, p.138. Ernst Cassirer described the relation between simplicity of form, generalised significance and mythological origin: 'For the sign, in contrast to the actual flow of the particular contents of consciousness, has a definite ideal meaning, which endures as such. It is not, like the simple given sensation, an isolated particular, occurring but once, but persists as the representative of totality, as an aggregate of potential contents, besides which it stands as a first 'universal'. In the symbolic function of consciousness – as it operates in language, in art, in myth – certain unchanging fundamental forms, some of a conceptual and purely sensory nature, disengage themselves from the stream of consciousness; the flux of contents is replaced by a self-contained and enduring unity of form.' *The Philosophy of Symbolic Forms. Volume One: Language*. Translated by Ralph Mannheim. New Haven: Yale University Press, 1953, p.89.

Selected Bibliography

1961 Alloway, Lawrence. *American Abstract Painters*. Exhibition catalogue. London: Arthur Tooth and Sons, 1961.

1961 Washburn, Gordon Bailey. *The 1961 Pittsburgh International Exhibition of Contemporary Painting and Sculpture*. Exhibition catalogue. Pittsburgh: Carnegie Institute, Department of Fine Arts, 1961.

1962 Gordon, John. *Geometric Abstraction in America*. Exhibition catalogue. Foreword by Eloise Spaeth. New York: Whitney Museum of American Art, 1962.

1963 Breeskin, Adelyn D. and Henry Geldzahler. *Paintings, Sculpture and Drawings by Ellsworth Kelly*. Exhibition catalogue. Washington, D.C.: Gallery of Modern Art, 1963.

1963 Geldzahler, Henry. *Toward a New Abstraction*. Exhibition catalogue. New York: The Jewish Museum, 1963, p.16–17.

1965 Geldzahler, Henry. *American Painting in the Twentieth Century*. New York: The Metropolitan Museum of Art, 1965: p.97, 129, 151–152.

1965 McConathy, Dale. *Kelly, 27 Lithographs*. Paris: Maeght Editeur, 1965.

1966 Annual Exhibition, 1966: *Contemporary Sculpture and Prints*. Exhibition catalogue. New York: Whitney Museum of American Art, 1966.

1967 Fry, Edward F. *Guggenheim International Exhibition 1967: Sculpture from Twenty Nations*. Exhibition catalogue. New York: The Solomon R. Guggenheim Museum, 1967.

1967 *New Work by Ellsworth Kelly*. Exhibition catalogue. New York: Sidney Janis Gallery, 1967.

1967 Rose, Barbara. *American Art Since 1900: A Critical History*. New York: Frederick A. Praeger, 1967: 229–231, 248, 267.

1968 *An Exhibition of Paintings & Sculpture by Ellsworth Kelly*. Exhibition catalogue. New York: Sidney Janis Gallery, 1968.

1970 Ashton, Dore. *Modern American Painting*. New York: The New American Library, 1970.

1971 Coplans, John. *Ellsworth Kelly*. New York: Harry N. Abrams, Inc., 1971.

1971 *Ellsworth Kelly*. Exhibition catalogue. Minneapolis: Dayton's Gallery 12, 1971.

1971 Waldman, Diane. *Ellsworth Kelly: Drawings, Collages, Prints*. Greenwich: New York Graphic Society Ltd., 1971.

1973 Goossen, E. C. *Ellsworth Kelly*. Exhibition catalogue. New York: The Museum of Modern Art, New York, 1973.

1974 *Nine Artists/Coenties Slip*. Exhibition catalogue. New York: Whitney Museum of American Art, downtown, 1974.

1976 *Ellsworth Kelly: Colored Paper Images*. New York: Tyler Graphics Ltd., 1976.

1978 *Ellsworth Kelly: Twelve Leaves*. Los Angeles: Gemini G.E.L., 1978.

1979 Baker, Elizabeth C. *Ellsworth Kelly: Recent Paintings and Sculptures*. Exhibition catalogue. New York: The Metropolitan Museum of Art, 1979.

1979 Rose, Barbara, de Wilde, E. and Kelly, E. *Ellsworth Kelly: The Focussed Vision, Ellsworth Kelly: Paintings and Sculptures, 1963–1979*. Exhibition catalogue in Dutch and English with *Notes from 1969* by Ellsworth Kelly. Amsterdam: Stedelijk Museum, 1979.

1980 Rose, Barbara and Katharina Schmidt. *Ellsworth Kelly: Gemälde und Skulpturen 1966–1979*. Exhibition catalogue in German. Baden-Baden: Staatliche Kunsthalle Baden-Baden, 1980.

1980 Rose, Barbara. *Ellsworth Kelly: Peintures et Sculptures 1968–1979*. Exhibition catalogue in French. Paris: Centre Georges Pompidou, 1980.

1981 *Ellsworth Kelly*. Exhibition catalogue. New York: Castelli/Blum Helman Gallery, 1981.

1982 Ratcliff, Carter. *Ellsworth Kelly at Gemini 1979–1982*. Exhibition catalogue. Los Angeles: Gemini G.E.L., 1982.

1984 *Ellsworth Kelly: Works in Wood*. Exhibition catalogue. New York: Blum Helman Gallery, 1984.

1987 Axsom, Richard H. *The Prints of Ellsworth Kelly: A Catalogue Raisonné 1949–1985*. New York: The American Federation of Arts, 1987.

1987 Fairbrother, Trevor J. Ellsworth *Kelly: Seven Paintings (1952–55/1987)*. Exhibition catalogue. Boston, Massachusetts: Museum of Fine Arts, 1987.

1987 Upright, Diane and Fort Worth Art Museum. *Ellsworth Kelly: Works on Paper*. Exhibition catalogue. New York: Harry N. Abrams, 1987.

1988 Besset, Maurice, et al. *La Couleur Seule, l'Expérience du Monochrome*. Exhibition catalogue. Lyon, France: Ville de Lyon avec la collaboration des Musées de France et le Centre National des Arts Plastiques, 1988.

1988 Storr, Robert. *'Kelly Now', Ellsworth Kelly: New Work*. Exhibition catalogue. New York: Blum Helman Gallery, November 1988.

1989 Bürgi, Bernhard. *256 Farben & Basics of Form*. Exhibition catalogue with essay by Ellsworth Kelly. Zürich: Stiftung für konstruktive und konkrete Kunst, 1989, p.46–47, 52–53.

1989 Rose, Barbara. *Ellsworth Kelly's New Paintings: The Search for Reasonable Order, Ellsworth Kelly: Curves/Rectangles*. Exhibition catalogue. New York: Blum Helman Gallery, November 1989.

1990 Kelly, Ellsworth. *Artist's Choice, Ellsworth Kelly: Fragmentation and the Single Form*. Exhibition pamphlet. New York: The Museum of Modern Art, 1990.

1991 Bernstein, Roberta. Exhibition catalogue. *Ellsworth Kelly: At Right Angles, 1964–1966*. Los Angeles: Margo Leavin Gallery, John Berggruen Gallery, and Paula Cooper Gallery, 1991.

1992 Ashbery, John. *Ellsworth Kelly Plant Drawings*. Exhibition Catalogue. New York: Matthew Marks Gallery, 1992.

1992 Boehm, Gottfried. *Form und Grund / Form and Ground, Ellsworth Kelly Yellow Curve*. Frankfurt, Germany: Portikus Frankfurt am Main, Edition Cantz, 1992.

1992 Bois, Yve-Alain. *Ellsworth Kelly, The Years in France, 1948–1954*. Exhibition catalogue. Washington, D.C.: National Gallery of Art, 1992.

1992 *Ellsworth Kelly*. Exhibition catalogue. New York: Blum Helman Gallery, 1992.

1993 Glimcher, Mildred. *Indiana, Kelly, Martin, Rosenquist, Youngerman at Coenties Slip*. Exhibition catalogue. New York: The Pace Gallery, 1993.

1994 Bois, Yve-Alain and Jack Shear. *Ellsworth Kelly: Spencertown*. Exhibition catalogue. London: Anthony d'Offay Gallery and New York: Matthew Marks Gallery, 1994.

1995 Kiehl, David. *Colored Paper Images 1976–1977: The Creative Process*, Ellsworth Kelly. Exhibition catalogue. New York: Susan Sheehan Gallery, 1995.

1996 Waldman, Diane. *Ellsworth Kelly: A Retrospective*. Exhibition catalogue. New York: Solomon R. Guggenheim Museum, 1996.

1997 Zweite, Armin. *'Ellsworth Kelly' Köln Skulptur1*. Exhibition catalogue. Köln: Wienand Verlag, 1997: 74, 160.

1998 Hickey, Dave. *Ellsworth Kelly's Oratorical Silence, Ellsworth Kelly New Paintings*. Exhibition catalogue. New York: Matthew Marks Gallery, 1998.

1999 *Ellsworth Kelly, Vanessa Beecroft, Jorge Pardo*, The Parkett Series with Contemporary Artists / Die Parkett-Reihe mit Gegenwartskünstlern 56. Essays by Thomas Kellein, Briony Fer, Simon Maurer, and David Rimanelli in English and German. Zürich: Parkett Verlag AG, September 1999: 13–75.

1999 Batchelor, David. *The Spectrum, and Other Colors, Ellsworth Kelly Spectrums*. Exhibition catalogue. New York: Mitchell-Innes & Nash, 1999.

1999 Bois, Yve-Alain. *Kelly's Trouvailles: Findings in France, Ellsworth Kelly: The Early Drawings, 1948–1955*. Exhibition catalogue in English and German. Cambridge, Massachusetts: Harvard University Art Museums; Switzerland: Kunstmuseum Winterthur, 1999.

1999 Cooper, Harry. *An Intense Detachment: Ellsworth Kelly's Line Form, Color Line Form Color*. Harvard University Art Museums: the President and Fellows of Harvard College, 1999.

1999 Perrott, Jeff. *The Way of Seeing, Ellsworth Kelly Plant Lithographs 1973–1997*. Exhibition catalogue. New York: Susan Sheehan Gallery, 1999.

2000 Jensner, Magnus. *A Century of Innocence: The History of the White Monochrome*. Exhibition catalogue. Malmö: Rooseum, 2000.

2000 Kirili, Alain. *La Sculpture Contemporaine au Jardin des Tuileries*. Exhibition catalogue in French with text by Catherine Tasca, Alain Kirili, and Robert Storr. Paris: La domaine national des Tuileries, le Centre des monuments nationaux, 2000.

2001 Bernstein, Roberta. *Ellsworth Kelly, Painter and Sculptor*. Georgia and David K. Welles Sculpture Garden Dedication, Toledo Museum of Art, June 1, 2001.

2001 Rich, Sarah. *Ellsworth Kelly Relief Paintings 1954–2001*. Exhibition catalogue. New York: Matthew Marks Gallery, 2001.

2001 Sims, Patterson and Emily Pulitzer. *Ellsworth Kelly: Sculpture*. Exhibition catalogue. New York: Whitney Museum of American Art, 1982.

2001 Stein, Laurie. *Abstractions in Space: Tadao Ando, Ellsworth Kelly, Richard Serra*. St. Louis: The Pulitzer Foundation for the Arts, 2001: 46–53.

2002 Boehm, Gottfried, Ellsworth Kelly, and Viola Weigel. *Ellsworth Kelly In Between Spaces, Works 1956–2002*. Exhibition catalogue. Ostfildern-Ruit: Fondation Beyeler and Hatje Cantz, 2002.

2002 LaBrusse, Rémi and Eric de Chassey. *Henri Matisse – Ellsworth Kelly: dessins de plantes*. Exhibition catalogue in French and English. Paris: Éditions Gallimard / Centre Georges Pompidou, 2002.

2003 Buchloh, Benjamin. *Ellsworth Kelly Matrix*. Exhibition catalogue. New York: Matthew Marks Gallery, 2003.

2003 Cooper, Harry. *Kelly's Selvage, Ellsworth Kelly: Self-Portrait Drawings 1944–1992*. Exhibition catalogue. New York: Matthew Marks Gallery, 2003.

2003 Kamps, Bernstein, et al. *Ellsworth Kelly: Red Green Blue. Paintings and Studies 1958–1965*. Exhibition catalogue. Museum of Contemporary Art San Diego: 2003.

2005 Axsom, Richard H. *Drawn from Nature – The Plant Lithographs of Ellsworth Kelly*. Exhibition catalogue. Grand Rapids Art Museum and Yale University Press, 2005.

2006 Whitfield, Sarah and Rochelle Steiner. *Ellsworth Kelly*. Exhibition catalogue. London: Serpentine Gallery, 2006.

Selected Exhibition History

1951 Galerie Arnaud, Paris, France

1956 Betty Parsons Gallery, New York
(also 1957, 1959, 1961 and 1963)

1959 *Sixteen Americans* at the Museum
of Modern Art, New York

1963 *Paintings, Sculpture and Drawings by
Ellsworth Kelly* at the Washington Gallery
of Modern Art, Washington, D.C. travels
to Institute of Contemporary Art, Boston

1964 *Documenta III*, Museum Fridericianum,
Kassel, Germany (also 1968, 1977, 1992)

1965 Sidney Janis Gallery, New York
(also 1967, 1968, 1971)

1966 *Venice Biennale*, Venice Italy
(also 2007)

1973 *Ellsworth Kelly* at the Museum of Modern
Art, New York travels to Pasadena Art
Museum, Pasadena, California; Walker
Art Center, Minneapolis, Minnesota; The
Detroit Institute of Arts, Detroit, Michigan

1979 *Ellsworth Kelly Recent Paintings and
Sculpture* at The Metropolitan Museum
of Art, New York

*Ellsworth Kelly: Painting and Sculpture
1963–1979* at Stedelijk Museum,
Amsterdam travels to Hayworth Gallery,
London; Centre George Pompidou, Paris;
Staatliche Kunsthalle, Baden-Baden

1982 *Ellsworth Kelly: Sculpture* at the Whitney
Museum of American Art, New York
travels to the Saint Louis Art Museum,
St. Louis, Missouri

1987 *Ellsworth Kelly: Works on Paper* at
Fort Worth Art Museum travels to Museum
of Fine Arts, Boston; Art Gallery of Ontario,
Toronto; The Baltimore Museum of Art;
San Francisco Museum of Modern Art;
and Nelson-Atkins Museum of Art,
Kansas City, Missouri

1992 Matthew Marks Gallery, New York
(also 1994, 1996, 1998, 1999, 2001, 2003)

1996 *Ellsworth Kelly: A Retrospective* at Solomon
R. Guggenheim Museum, New York travels
to Museum of Contemporary Art,
Los Angeles; Tate Gallery, London;
and Haus der Kunst, Munich

1998 *Ellsworth Kelly: On the Roof* at The Iris
and B. Gerald Cantor Roof Garden,
The Metropolitan Museum of Art, New York

1999 *Ellsworth Kelly: The Early Drawings
1948–1955*, Fogg Art Museum, Harvard
University, Cambridge travels to High
Museum of Art, Atlanta; Art Institute
of Chicago; Kunstmuseum Winterthur;
Städtische Galerie im Lenbachhaus,
Munich; and Kunstmuseum Bonn

2002 *Henri Matisse/Ellsworth Kelly: dessins de plantes*, Centre George Pompidou, Musée National d'Art Moderne, Paris travels to Saint Louis Art Museum

Ellsworth Kelly: Tablet 1948–1973, at The Drawing Center, New York travels to Musée Cantonal des Beaux-Arts, Lausanne

Selected Works by Ellsworth Kelly in Saint Louis Collections, The Pulitzer Foundation, Saint Louis, Missouri

Ellsworth Kelly in San Francisco Collections at the San Francisco Museum of Modern Art

Ellsworth Kelly: Works 1956–2002 at Fondation Beyeler, Basel, Switzerland

2003 *Ellsworth Kelly: Red Green Blue* at San Diego Museum of Contemporary Art, travels to Museum of Fine Arts, Houston and Whitney Museum of American Art, New York

National Gallery of Art exhibits *Color Panels for a Large Wall*, 1978

2004 *Ellsworth Kelly in Dallas* at the Dallas Museum of Art

Eva Hesse, Jasper Johns, Ellsworth Kelly, Gerhard Richter at the Art Institute of Chicago

2005 *Ellsworth Kelly: Small Paintings – 1955–1963*, Peter Freeman, Inc., New York

Ellsworth Kelly: Tablet, The Menil Collection, Houston

Drawn from Nature – The Plant Lithographs of Ellsworth Kelly, Grand Rapids Art Museum travels to Hood Museum, Dartmouth College, Hanover, New Hampshire; Tate Gallery, St. Ives; AXA Gallery, New York; Centro Andaluz de Arte Contemporaneo, Seville

2006 *Ellsworth Kelly* at Serpentine Gallery, London

Ellsworth Kelly Paris – New York 1949–1959 at Philadelphia Museum of Art

Ellsworth Kelly: New Paintings and *Ellsworth Kelly: Drawings on a Bus – Sketchbook 23, 1954* at Matthew Marks Gallery, New York

2007 Premiere of Checkerboard Film Foundation documentary, *Ellsworth Kelly: Fragments*

UK £16.95	US $29.95	CAN $38.95

ISBN 978-1-85437-630-5

9 781854 376305